JOSHUA
LEADER GUIDE

Joshua

WINNING *the* WORRY Battle

A Bible Study by

Barb Roose

Leader Guide
Jenny Youngman, Contributor

Abingdon Women / Nashville

Joshua
Winning the Worry Battle
Leader Guide

ISBN 978-1-5018-1362-7

18 19 20 21 22 23 24 25 26 27 — 10 9 8 7 6 5 4 3 2 1
MANUFACTURED IN THE UNITED STATES OF AMERICA

CONTENTS

ABOUT THE AUTHOR

Barb Roose is a popular speaker and author who is passionate about connecting women to one another and to God, helping them apply the truths of God's Word to the practical realities and challenges they face as women in today's culture. Barb enjoys teaching and encouraging women at conferences and events across the country, as well as internationally. She is the author of the *Joshua: Winning the Worry Battle* and *Beautiful Already: Reclaiming God's Perspective on Beauty* Bible studies and the books *Winning the Worry Battle: Life Lessons from the Book of Joshua* and *Enough Already: Winning Your Ugly Struggle with Beauty.* She also writes a regular blog at BarbRoose.com and hosts the "Better Together" podcast. Previously Barb was Executive Director of Ministry at CedarCreek Church in Perrysburg, Ohio, where she served on staff for fourteen years and co-led the annual Fabulous Women's Conference that reached more than ten thousand women over five years. Barb and her husband, Matt, live in Toledo, Ohio, and are the parents of three beautiful daughters.

Follow Barb:

Twitter @barbroose
Facebook Facebook.com/barbararoose
Instagram @barbroose
Blog BarbRoose.com
 (check here for event dates and booking information)

INTRODUCTION

If you have you ever found yourself worrying about the bad things that could happen—whether they involve your family, your job, your finances, your health, your future, or our nation or world—then this study is for you. Let's face it, it's for all of us! As Christians, we know that we shouldn't worry, but the reality is that we all do at times. And when we try to fight worry with faith, often we feel that we're losing the battle. In those moments, well-intentioned comments like "God's got this!" or "Just pray about it" can leave us feeling even more burdened. Whether it's personal worries or broader concerns, we long for something more than clichés that will help us put real feet to our faith and win the worry battle.

There was a time in my life when I was losing the worry battle. In a fallen world filled with bad news, bad people, and bad decisions, worry felt like a handy strategy to keep me on my toes. I thought that if I could answer all of the "what ifs," then maybe I could prevent some unknown inconvenience, pain, or tragedy in the future. Those "what if" questions popped up in every area of my life, and it seemed to make sense to try to find answers to them. Oh, the hours I spent thinking, rethinking, and overthinking all of the uncertainties in my life! *What would happen if…* But then something changed. I wish that I could tell you that I prayed for God to take away my worry and, suddenly, it disappeared and never came back. That hasn't happened, but something even more amazing has! Over the years, God has equipped me to block, battle, and beat back worry from my life. Worry will always be a threat, but I'm not powerless against it. And neither are you! We can and must fight the worry battle, but we won't be able to win on our own. *God* will give us victory!

My worry battle is one of the reasons I was drawn to the Book of Joshua. Imagine the "what if" questions in the minds of millions of Israelites who'd traveled for many years to a place where they had never been before. They faced the kind of worries that you might be facing right now, such as what they would encounter next, where they would live, and how they would survive. They faced a battle not only with worry but also with very real enemies.

In this six-week study on the Book of Joshua, we will join God's people as they arrive in the hostile territory of Canaan and are surrounded by great uncertainty and

formidable foes. Even though God gave the land to the Israelites more than four hundred years before, they had to fight for and claim it. We'll see how God promised and paved the way to victory for His people when they showed up and fought in faith.

Along the way, we'll get to know the man Joshua, who led the Israelites in this fight. Joshua has been a hero of mine for many years, even inspiring me to jump out of an airplane (I'll share about that during our study)! He almost seemed invincible to me; but as I studied how God communicated with Joshua, I realized that he likely fought his own worry battle. How encouraging it is to know that one of the Bible's most faithful heroes had to battle worry, too.

So, I invite you and your group to join me on the battlefield as we learn to overcome a struggle that so many of us face each day. Whether you have worried, panicked, or even had a massive meltdown over friendship, family, financial, or future-related issues, God has a new path for you to follow. Joshua and the Israelites will show us the way, teaching us how to join forces with God and *win* over worry!

About the Participant Book

Before the first session, you will want to distribute copies of the participant book to the members of your group. Be sure to communicate that they are to complete the first week of readings *before* your first group session. For each week there is a Scripture memory verse and five readings or lessons that combine study of Scripture with personal reflection and application (color boldface type indicates write-in-the-book questions and activities). Each lesson ends with an "Apply It" experience, a prayer, and a takeaway for the day. On average each lesson can be completed in about twenty to thirty minutes. Completing these readings each week will prepare the women for the discussion and activities of the group session.

About This Leader Guide

As you gather each week with the members of your group, you will have the opportunity to watch a video, discuss and respond to what you're learning, and pray together. You will need access to a television and DVD player with working remotes.

Creating a warm and inviting atmosphere will help make the women feel welcome. Although optional, you might consider providing snacks for your first meeting and inviting group members to rotate in bringing refreshments each week.

This leader guide and the DVD will be your primary tools for leading each group session. In this book you will find outlines for six group sessions, each formatted for either a 60-minute or 90-minute group session:

60-Minute Format

Leader Prep (Before the Session)

Welcome and Opening Prayer	2 minutes
Icebreaker	3 minutes
Video	20–25 minutes
Group Discussion	25 minutes
Closing Prayer	3–5 minutes

90-Minute Format

Leader Prep (Before the Session)

Welcome and Opening Prayer	2 minutes
Icebreaker	3 minutes
Video	20–25 minutes
Group Discussion	25–40 minutes
Deeper Conversation	15 minutes
Closing Prayer	5 minutes

As you can see, the 90-minute format is identical to the 60-minute format but has more time for group discussion plus a deeper conversation exercise for small groups. Feel free to adapt or modify either of these formats, as well as the individual segments and activities, in any way to meet the specific needs and preferences of your group.

Here is a brief overview of the elements included in both formats:

Leader Prep (Before the Session)

For your preparation prior to the group session, this section provides an overview of the week's Bible story and theme, the main point of the session, key Scriptures, and a list of materials and equipment needed. Be sure to review this section, as well as the session outline, before the group to plan and prepare. If you choose, you also may find it helpful to watch the DVD segment in advance.

Welcome and Opening Prayer (2 minutes)

To create a warm, welcoming environment as the women are gathering before the session begins, consider lighting one or more candles, providing coffee or other refreshments, and/or playing worship music. (Bring a smartphone or tablet and a portable speaker if desired.) Be sure to provide name tags if the women do not know one another or you have new participants in your group. Then, when you are ready to begin, pray the opening prayer that is provided or offer your own. You also may find it helpful to read aloud the Bible Story Overview found in the Leader Prep section if not all group members have completed their homework.

Icebreaker (3 minutes)

Use the icebreaker to briefly engage the women in the topic while helping them feel comfortable with one another.

Video (20–25 minutes)

Next, watch the week's video segment together. Be sure to direct participants to the Video Viewer Guide in the participant book, which they may complete as they watch the video. (Answers are provided on page 206 of the Participant Workbook and page 61 of this Leader Guide.)

Group Discussion (25–40 minutes, depending on session length)

After watching the video, choose from the questions provided to facilitate group discussion (questions are provided for both the video and the participant workbook). For the workbook portion, you may choose to read aloud the discussion points—which are excerpts from the participant workbook—or express them in your own words; then use one or more of the questions that follow to guide your conversation.

Note that more material is provided than you will have time to include. Before the session, select what you want to cover, putting a check mark beside it in your book. Reflect on each question and make some notes in the margins to share during your discussion time. Page references are provided for those questions that relate to specific questions or activities in the participant workbook. For these questions, invite group members to turn in their workbooks to the pages indicated. Participants will need Bibles in order to look up various supplementary Scriptures.

Depending on the number of women in your group and the level of their participation, you may not have time to cover everything you have selected, and that is okay. Rather than attempting to bulldoze through, follow the Spirit's lead and be open to where the Spirit takes the conversation. Remember that your role is not to have all the answers but to encourage discussion and sharing.

Deeper Conversation (15 minutes)

If your group is meeting for 90 minutes, move next to this exercise for deeper sharing in small groups, dividing into groups of two or three. This is a time for women to share more intimately and build connections with one another. (Encourage the women to break into different groups each week.) Before the session, write the question or questions you want to discuss on a markerboard or chart paper for all to see. Give a two-minute warning before time is up so that the groups may wrap up their discussion.

Closing Prayer (3–5 minutes, depending on session length)

Close by leading the group in prayer. Invite the women to briefly name prayer requests. To get things started, you might share a personal request of your own. As women share their requests, model for the group by writing each request in your participant workbook, indicating that you will remember to pray for them during the week.

As the study progresses, you might encourage members to participate in the Closing Prayer by praying out loud for each other and the requests given. Ask the women to volunteer to pray for specific requests, or have each woman pray for the woman on her right or left. Make sure name tags are visible so that group members do not feel awkward if they do not remember someone's name.

After the prayer, remind the women to pray for one another throughout the week.

Before You Begin

I am so grateful that you have chosen to lead a group through this study on Joshua. The goal of the study is to equip each of you to "win" the battle against fear and worry in your lives as you learn from Joshua how to stay close to God and rely on Him even in the middle of challenging circumstances and uncertainty—especially then. As group leader, your role is to guide and encourage the women as they move throughout the journey, and I want you to know that I have been praying for *you*. Though I don't know your name or the specifics of your story and your own struggle with worry, God does. He was thinking of you as I was writing, He has called you to lead this study, and you can trust Him to lead you and your group to victory! May the words of Joshua 1:9 encourage you on your journey:

> *Be strong and courageous. Do not be frightened, and do not be dismayed, for the Lord your God is with you wherever you go.*
>
> *(Joshua 1:9 ESV)*

Barb

LEADER HELPS

Preparing for the Sessions

- Decide whether you will use the 60-minute or 90-minute format option. Be sure to communicate dates and times to participants in advance.
- Distribute participant books to all members at least one week before your first session and instruct them to complete the first week's readings. If you have the phone numbers or e-mail addresses of your group members, send out a reminder and a welcome.
- Check out your meeting space before each group session. Make sure the room is ready. Do you have enough chairs? Do you have the equipment and supplies you need? (See the list of materials needed in each session outline.)
- Pray for your group and each group member by name. Ask God to work in the life of every woman in your group.
- Read and complete the week's readings in the participant book and review the session outline in the leader guide. Select the discussion points and questions you want to cover and make some notes in the margins to share in your discussion time.

Leading the Sessions

- Personally welcome and greet each woman as she arrives. Have everyone sign the group roster (see page 62).
- At the start of each session, ask the women to turn off or silence their cell phones.
- Always start on time. Honor the time of those who are on time.
- Encourage everyone to participate fully, but don't put anyone on the spot. Invite the women to share as they are comfortable. Be prepared to offer a personal example or answer if no one else responds at first.

- Communicate the importance of completing the weekly readings and participating in Group Discussion.
- Facilitate but don't dominate. Remember that if you talk most of the time, group members may tend to listen rather than to engage. Your task is to encourage conversation and keep the discussion moving.
- If someone monopolizes the conversation, kindly thank her for sharing and ask if anyone else has any insights.
- Try not to interrupt, judge, or minimize anyone's comments or input.
- Remember that you are not expected to be the expert or have all the answers. Acknowledge that all of you are on this journey together, with the Holy Spirit as your leader and guide. If issues or questions arise that you don't feel equipped to handle or answer, talk with the pastor or a staff member at your church.
- Don't rush to fill the silence. If no one speaks right away, it's okay to wait for someone to answer. After a moment, ask, "Would anyone be willing to share?" If no one responds, try asking the question again a different way—or offer a brief response and ask if anyone has anything to add.
- Encourage good discussion, but don't be timid about calling time on a particular question and moving ahead. Part of your responsibility is to keep the group on track. If you decide to spend extra time on a given question or activity, consider skipping or spending less time on another question or activity in order to stay on schedule.
- Try to end on time. If you are running over, give members the opportunity to leave if they need to. Then wrap up as quickly as you can.
- Thank the women for coming and let them know you're looking forward to seeing them next time.
- Be prepared for some women to want to hang out and talk at the end. If you need everyone to leave by a certain time, communicate this at the beginning of the group session. If you are meeting in a church during regularly scheduled activities, be aware of nursery closing times.

ON THE EDGE OF UNCERTAINTY

Facing Our Fears
(Joshua 1)

Leader Prep

Bible Story and Theme Overview

This week we've been introduced to Joshua, who will take the reins from Moses and lead the Israelites into the Promised Land. Naturally, he has some fears to face, but Joshua teaches us to trust God when we're at the edge of uncertainty. Joshua has to depend on the hard fact that God has promised to be with him wherever he goes, even straight into battle.

Main Point

God's command to Joshua to be strong and courageous (Joshua 1:9) isn't a command to fake it until he feels it. Joshua actually is to *assume* strength and courage before he ever goes into his first battle. God wants to dig Joshua's strength-and-courage well and fill it up before he ever needs it. And when it comes to the worry battle, God wants to do the same for us. If we will give Him the time and commitment to retool our hearts and minds, He will set us up for victory before worry even shows up to start a fight.

Key Scriptures

Have I not commanded you? Be strong and courageous. Do not be frightened, and do not be dismayed, for the LORD your God is with you wherever you go.

(Joshua 1:9 ESV)

25 "That is why I tell you not to worry about everyday life—whether you have enough food and drink, or enough clothes to wear. Isn't life more than food, and your body more than clothing? 26 Look at the birds. They don't plant or harvest or store food in barns, for your heavenly Father feeds them. And aren't you far more valuable to him than they are? 27 Can all your worries add a single moment to your life?"

(Matthew 6:25-27)

"Father, if you are willing, please take this cup of suffering away from me. Yet I want your will to be done, not mine."

(Luke 22:42)

What You Will Need

- *Joshua* DVD and a DVD player
- Markerboard or chart paper and markers
- Stick-on name tags and markers (optional)
- Smartphone or tablet and portable speaker (optional)

Session Outline

Welcome and Opening Prayer (2 minutes)

To create a warm, welcoming environment as the women are gathering before the session begins, consider lighting one or more candles, providing coffee or other refreshments, and/or playing worship music. (Bring a smartphone or tablet and a portable speaker if desired.) Be sure to provide name tags if the women do not know one another or you have new participants in your group. Then, when you are ready to begin, pray the following prayer or offer your own:

Dear God, we are so grateful that You give us the strength and courage to face any fear that comes against us. Help us to stand in Your Word and Your presence when we are overcome with worry. Come fill us now as we study and share together. Amen.

Icebreaker (3 minutes)

Invite the women to share short, "popcorn" responses to the following question:

- What is your "eight-legged worry"?

Video (20–25 minutes)

Play the Week 1 video segment on the DVD. Invite participants to complete the Video Viewer Guide for Week 1 in the participant workbook as they watch (page 39).

Group Discussion (25–35 minutes, depending on session length)

Note: More material is provided than you will have time to include. Before the session, select what you want to cover, putting a check mark beside it in your book. Page references are provided for questions related to questions or activities in the participant workbook. For these questions, invite participants to share the answers they wrote in their books.

Video Discussion Questions

- What is a "what if" question that has caused you to worry recently? How might insecurity be at the heart of that worry?
- What has worry stolen from your life?
- What are the three kinds of victory that God gave to Joshua? Which of these three kinds of victory do you most need in your life right now, and why?
- Practically speaking, how might you begin to replace "what if" thoughts with "God, if..." prayers? How could believing that God is with you and for you in *every* circumstance change your life?

Participant Workbook Discussion Questions

1. Worrying begins when you face unpredictable situations and you don't know what will happen next. I don't like it when I can't see what's coming. I'm not comfortable when I can't name or prevent the dangers that lurk down the street and around the corner. All of those unknown events in my life and yours are what we call uncertainty. (Day 1)

 - Are you dealing with an area of uncertainty in your life? If so, what feels open-ended and unknown? (page 15)
 - How do uncertainty and worry manifest themselves in your day-to-day life?
 - How comfortable are you with uncertainty? Why do you think that is?

2. Jesus taught on a hillside to a crowd of people from all walks of life. But everyone in the crowd had something in common: they worried. How do we know they worried? Because Jesus was teaching on it!

 If you've been feeling guilty because you worry too much, I encourage you to let go of that guilt. Jesus taught on worry because He knew that it would be a struggle for us. You aren't alone in your struggle. (Day 1)

- Read Matthew 6:25-27. What three things does Jesus tell us not to worry about? (page 16)
- Look at verse 27. How productive is worry? (page 16)
- How do Jesus' words apply to your life *right now*? (page 16)

3. As the Book of Joshua opens, millions of Israelite men, women, and children stand clustered together east of the Jordan River. Before his death, their leader Moses had gathered all the people to tell them what to expect, what to do, and how to live. Even with all of that new knowledge, I'm sure there were a few people with some lingering worries or concerns. Now Moses has died, and their new leader, Joshua, stands before the people. (Day 2)

- What might some of Joshua's worries have been?
- What might some of the Israelites' worries have been?
- What would you say was their only course of action in the face of change and uncertainty?

4. You can't worry and trust God at the same time. When you say "Father, if...," you acknowledge that even if bad people make bad decisions that hurt or harm you, God is still with you. Likewise, when you say "Father, if..." and then bad situations break your heart or kill your dreams, you've already invited God's power to bring about blessing in the midst of brokenness and pain. (Day 2)

- How will your life be different if you stop worrying? (page 21)
- Why do you think that God wants you to be victorious over worry? (page 21)
- Read Luke 22:42. How does Jesus' obedience teach us to trust God instead of worry?

5. One of the major themes in the Book of Joshua is that God always keeps His promises. Canaan wasn't just an idea that God came up with while the Israelites were wandering around. God wasn't panicked, thinking that maybe He should get them off the road and settled because they'd been adrift for too long. In fact, God was about to bring a promise to pass that He'd made many centuries before. Long before the Israelites arrived at the eastern edge of the Jordan, God had made a promise to a man named Abram, later renamed Abraham. (Day 3)

- Read Genesis 12:1-3. What did God promise Abram? (page 23)
- Read Joshua 1:3. What has God promised Joshua? (page 24)
- Read Joshua 1:4-5. What are the next promises that God makes to Joshua? (page 24)

6. I'm not sure if Joshua knew in advance that he'd lead the Israelites into the Promised Land. But if he did, I imagine that despite years of preparation, the weight of that impeding role still would have felt heavy on his shoulders.

 We're no different. With every new opportunity comes an unknown frontier. So, whenever we're not sure about what we're facing, the most important thing that we can do is look up. (Day 3)

 - When have you felt the weight of an unknown frontier or new responsibility? In what ways did you "look up" during that time? (pages 26–27)
 - Read Deuteronomy 31:7-8. What guarantee does Moses give Joshua regarding God's help? (page 27)
 - Read Hebrews 13:6. Why do we not need to fear? (page 27)

7. While the words "warrior" and "worrier" begin and end with the same letters, what happens in-between tells the real story. When I think about the "a" in warrior, I associate it with "anchored." A warrior knows who she is and doesn't get swept away by worries that tell her otherwise. Conversely, I associate the "o" in worrier with "overpowered." A worrier is overpowered by her negative thinking patterns and cannot control them. (Day 4)

 - How do God's instructions to Joshua in chapter 1, verse 6 help him move from worrier to warrior?
 - How difficult is it for you to decide to be strong and courageous in the face of adversity?
 - What keeps you from standing in strength and courage?

8. If God had to continually remind this valiant soldier, faithful assistant to Moses, and spy who stood up to the people, then maybe Joshua might understand what it's like for me to battle worry, too. (Day 4)

 - What are some of the things that Joshua might worry about as the leader of the Israelite families and army? (page 31)
 - If you asked the people who are closest to you whether you are a worrier or a warrior, which do you think they would choose? Why? (page 31)
 - Read aloud Joshua 1:7, 8, and 16. What are some of the outcomes that God promises Joshua will experience if he leads with strength and courage? (page 32)

9. While Joshua's purpose was to lead the Israelites into the Promised Land, his priorities were to stay connected to God's teachings, be committed to obedience, and remain conscious of God's activity within and all around him. Having a job that would require life and death situations as well as the leadership of millions, Joshua surely knew that he had to put first things first. (Day 5)

 - Read Deuteronomy 30:16 and Joshua 1:8. How do these verses help shape our priorities and remind us what's important in the face of uncertainty or challenges?
 - What does it mean to seek God first above all else? (page 35)
 - Read Matthew 6:33. Where should we look first for answers to life's uncertainties, and what is the promised result? (page 35)

10. If Joshua were standing before you, he could list the many responsibilities that he had as a military leader. Yet God's plan for Joshua's victory had nothing to do with his military duties or even a daily task list. God directed Joshua's attention toward the maintenance of his soul. For all of the obligations and situations in his life screaming DO, God invited Joshua to BE—to focus on God and God's Word, and to live out of that focus. Like Joshua, God calls us to devote time every day to the soul-enriching, life-ordering practice of focusing on Him. (Day 5)

 - Is your life more about DO or BE right now? What's screaming DO in your life? (page 36)
 - What do you think God might be able to do in your life if you were a little less DO and a little more BE? (page 37)
 - What can you do to increase your wisdom-thoughts so that they outnumber your worry-thoughts? (page 37)

11. Think about all of your study and reflection this week.

 - What thoughts or discoveries are sticking with you from this week's study?

Deeper Conversation (15 minutes)

Divide into smaller groups of two or three for deeper conversation. (Encourage the women to break into different groups each week.) Before the session, write on a markerboard or chart paper the question or questions you want the groups to discuss:

- What victory are you celebrating this week?
- Look back at your Worry Wheel on page 33 in the participant workbook. Discuss any thoughts, insights, or surprises that stand out to you as you evaluate your level of worry.

Give a two-minute warning before time is up so that the groups may wrap up their discussion.

Closing Prayer (3–5 minutes, depending on session length)

Close the session by taking personal prayer requests from group members and leading the group in prayer. As you progress to later weeks in the study, you might encourage members to participate in the Closing Prayer by praying out loud for each other and the requests given.

GOD, KNOCK DOWN MY WORRY WALLS!

Letting God Fight for Us
(Joshua 2–6)

Leader Prep

Bible Story and Theme Overview

This week we met Rahab, an unlikely character who became a key player because of her willingness to obey God. She was an outsider and one who had only heard the stories about God's people, but she knew that God's plan was to be taken seriously. Joshua and Rahab continue to teach us about trusting God's plan for victory over our own.

Main Point

Our victory is determined by who God is, not what we are facing!

Key Scriptures

…for the Lord your God is God in heaven above and on the earth below.
(Joshua 2:11b NIV)

To whom shall I speak and give warning,
* that they may hear?*
Behold, their ears are uncircumcised,
* they cannot listen;*

*behold, the word of the L*ORD *is to them an object of scorn;*
they take no pleasure in it.
 (Jeremiah 6:10 ESV)

¹God is our refuge and strength,
 always ready to help in times of trouble.
²So we will not fear when earthquakes come
 and the mountains crumble into the sea.
³Let the oceans roar and foam.
 Let the mountains tremble as the waters surge!
 (Psalm 46:1-3)

What You Will Need

- *Joshua* DVD and a DVD player
- Markerboard or chart paper and markers
- Stick-on name tags and markers (optional)
- Smartphone or tablet and portable speaker (optional)

Session Outline

Welcome and Opening Prayer (2 minutes)

To create a warm, welcoming environment as the women are gathering before the session begins, consider lighting one or more candles, providing coffee or other refreshments, and/or playing worship music. (Bring a smartphone or tablet and a portable speaker if desired.) Be sure to provide name tags if the women do not know one another or you have new participants in your group. Then, when you are ready to begin, pray the following prayer or offer your own:

Dear God, thank You for being our Refuge and our Strength. Thank You for Your promises all through the Scriptures that You are with us and will fight for us. We invite You to speak through our study and conversation today. Amen.

Icebreaker (3 minutes)

Invite the women to share short, "popcorn" responses to the following question:

- Barb was invited to face her fears by jumping out of an airplane. What is your "airplane"? What scary thing would you do to tangibly conquer a fear?

Video (20–25 minutes)

Play the Week 2 video segment on the DVD. Invite participants to complete the Video Viewer Guide for Week 2 in the participant workbook as they watch (pages 70–71).

Group Discussion (25–35 minutes, depending on session length)

Note: More material is provided than you will have time to include. Before the session, select what you want to cover, putting a check mark beside it in your book. Page references are provided for questions related to questions or activities in the participant workbook. For these questions, invite participants to share the answers they wrote in their books.

Video Discussion Questions

- When have you had a worry meltdown? How did it help you to see your limitations and turn to God?
- What can keep us from turning to God after a meltdown? Why do you think we're often reluctant to take our sin and questions and pain to God?
- How has remembering that God is always with you helped you to weather a storm in your life?
- Barb says that God's very best gifts are the gifts that He brings to us, rather than the gifts we have to take for ourselves. What are some of God's best gifts to you?
- What helps you to keep your mind fixed and focused on God?

Participant Workbook Discussion Questions

1. We know that we're rushing ahead of God when we start to worry about details. On the other hand, when we wait on God to lead us, we are far enough back to let Him pave the way for us. (Day 1)

 - Read Joshua 3:2-3. What instructions are the people given? (page 42)
 - Has there been a time when you rushed ahead of God instead of waiting on His timing? If so, how did you know that you were rushing ahead of Him? (page 43)
 - Which one is more difficult for you: letting God lead or trying not to overtake God's lead? Why? (page 44)

2. God commands them to make the memorial so that as they travel by it, they will be reminded of what God did that day. And it won't just be the Israelites who will be reminded; anyone traveling by the memorial might inquire about the stones later and hear the story. (Day 1)

- Read Joshua 4:2-8. What does God instruct Joshua to do? What does Joshua say about the purpose of the memorial? (pages 45–46)
- Why do we need reminders to mark the moments in our lives when we have visibly seen the faithfulness of God? What are some markers in your own life of God's faithfulness?

3. When we're stubborn or closed off from a relationship, it might seem that we are getting our way, but what's really happening is that we're missing out on the blessing of connection. A covenant is for the blessing and benefit of both parties who have entered into agreement. (Day 2)

 - Read Leviticus 26:40-42. What does an uncircumcised heart represent? (page 49)
 - Can you think of a time when you were stubborn or closed off toward something that God was calling you to do? If so, briefly describe it. (page 49)
 - Read Jeremiah 6:10. How are "they" in this passage missing out on the blessing of connection?

4. God is the best heart doctor ever! He knows exactly what's wrong with our hearts, and when we are willing, He performs surgery on us. Just as a doctor uses scalpels and sponges to do her work, the Bible and the Holy Spirit are God's tools.

 The key to allowing God to circumcise our hearts can be captured in a word: *willingness.* (Day 2)

 - What are some of the ways that a willing heart connects with God? (page 51)
 - What does it mean to have a willingness for God to work on your heart? Is it easy or difficult to live in a place of willingness?
 - When have you felt God at work on your heart?

5. God uses ordinary, imperfect, and often unlikely people—even the poorest or lowest of society—to accomplish His purposes. Rahab is an example. (Day 3)

 - Review Joshua chapter 2. Who is Rahab? Why is she part of the Israelites' story?
 - Read verse 11. How does Rahab describe what happened to the hearts of the people of Jericho? (page 56)
 - How is your heart right now? Do you feel strong and courageous, or is there a situation causing your heart to melt in fear? Describe the reason for your response. (page 56)

6. The people of Canaan worshiped many gods, so it's significant for Rahab to declare the Israelites' God as the Supreme Being—the supreme God in the heavens above and the earth below. It's crazy that a prostitute living inside the walls of a pagan city displays greater faith in God's promises than God's chosen people who have seen God help them overcome their enemies and provide manna to eat each day. (Day 3)

 • Read Hebrews 11:1. What is the definition of faith? (page 57)
 • Does thinking of uncertainty as a friend to faith change your perspective in any way? If so, how? (page 57)
 • Read Joshua 2:12. What does Rahab ask the spies to do? (page 57) How do the spies respond to her request?

7. Joshua may be a valiant warrior and leader, but it isn't his battle. It is God's battle. And the "commander of the Lord's army" has come to remind Joshua of this important fact before he goes into battle.

 The same goes for us. Whatever battle you are fighting right now isn't actually your battle. (Day 4)

 • What does it mean that God will fight for us?
 • When have you seen God fight for someone or something? What was the outcome?
 • When have you experienced God going into battle just for you? for your marriage? for your children? for a friendship? for a calling?

8. When God fights, He doesn't actually need our help. The worst thing that we can do in the midst of uncertainty is think we're on God's side while expecting God to fight our way. We must beware of filling uncertainty with our expectations. (Day 4)

 • Read Joshua 6:1-5, 10. What battle plan does God give Joshua, and how will Jericho's wall fall down? (page 62)
 • How might that plan be different from the plan Joshua would have come up with on his own? What do you think Joshua might have planned instead?
 • Are there any fights where you need to back off and let God fight for you? (page 61) Is that easy or difficult for you to do, and why?

9. So often we think that stepping out in faith is about taking an act of faith, but God has called us to a life of faith. This means that there often will be places in our lives where we don't know what's next. But as Rahab discovered, as long as we dwell with God, He is our safe place. (Day 5)

- Now that they have been rescued, what testimony do you think that Rahab and her family are sharing with the rest of the Israelites? And how do you think that her faith encourages them as they move into the Promised Land? (page 68)
- Read Psalm 46:1-3. How do these verses describe God? (page 68) What does it mean that God is a refuge?
- Read the following verses: Psalm 18:2; Psalm 71:3; Psalm 91:2; and Proverbs 18:10. How are these verses an encouragement to live a life of faith, no matter the uncertainties, challenges, or fears we face?

10. We may be facing uncontrollable circumstances, but God's ability to deliver victory is based not on the situation but only on who He is!

I don't know what you are facing today, but the same God who dropped the walls of Jericho is on the job in your life today. You may feel like Rahab waiting to be saved from a difficult situation. If that is you, then hang on to Jesus today! (Day 5)

- What does victory over your uncontrollable circumstances mean to you?
- What have you learned from Joshua and Rahab about trusting that God is who God says He is?
- How would you explain the difference between our finite circumstances and God's infinite power? Is it easy or difficult for you to believe that God can save you from life's uncertainties? Why?

11. Think about all of your study and reflection this week.

- What thoughts or discoveries are sticking with you from this week's study?

Deeper Conversation (15 minutes)

Divide into smaller groups of two or three for deeper conversation. (Encourage the women to break into different groups each week.) Before the session, write on a markerboard or chart paper the question or questions you want the groups to discuss:

- Where have you experienced victory in your worry battle this week?
- Discuss your experience with the "Seven Minutes of Silence" challenge. Did the silence quiet your worries? Did you hear from God about a fear you are facing?

Give a two-minute warning before time is up so that the groups may wrap up their discussion.

Closing Prayer (3–5 minutes, depending on session length)

Close the session by taking personal prayer requests from group members and leading the group in prayer. As you progress to later weeks in the study, you might encourage members to participate in the Closing Prayer by praying out loud for each other and the requests given.

FIGHTING FRIENDS TO HELP US

Getting into Position
(Joshua 7–8)

Leader Prep

Bible Story and Theme Overview

This week, we have been journeying with the Israelites during a very difficult and worry-filled season of their early days in Canaan. They were doing great after Jericho and then, bam! Someone committed a sin, and they experienced a setback followed by a meltdown before God got them back on track to experience victory. We also met some "Fighting Friends" that God has given to us for the worry battle. These Fighting Friends will help us get into position to "fight in faith," which is more about *how* we fight than who or what we are fighting. These Fighting Friends actually position us to receive God's power so that we can live the abundant life Jesus promised us.

Main Point

When stress and fear are mounting, we can avoid a meltdown by pouring out our hearts to God.

Key Scriptures

Study this Book of Instruction continually. Meditate on it day and night so you will be sure to obey everything written in it. Only then will you prosper and succeed in all you do.

<div align="right">(Joshua 1:8)</div>

This Book of the Law shall not depart from your mouth, but you shall meditate on it day and night, so that you may be careful to do according to all that is written in it. For then you will make your way prosperous, and then you will have good success.

<div align="right">(Joshua 1:8 ESV)</div>

What You Will Need

- *Joshua* DVD and a DVD player
- Markerboard or chart paper and markers
- Stick-on name tags and markers (optional)
- Smartphone or tablet and portable speaker (optional)

Session Outline

Welcome and Opening Prayer (2 minutes)

To create a warm, welcoming environment as the women are gathering before the session begins, consider lighting one or more candles, providing coffee or other refreshments, and/or playing worship music. (Bring a smartphone or tablet and a portable speaker if desired.) Be sure to provide name tags if the women do not know one another or you have new participants in your group. Then, when you are ready to begin, pray the following prayer or offer your own:

Dear God, what a mighty, faithful, loving God You are. Thank You for fighting for us. Thank You for promising to be with us in the middle of our fears and worries. Help us to practice a life of leaning in to Your presence. Meet with us now as we look to You. Amen.

Icebreaker (3 minutes)

Invite the women to share short, "popcorn" responses to the following questions:

- What is your favorite workout routine? Why?
- What is your funniest "attempt at fitness" story?

Video (20–25 minutes)

Play the Week 3 video segment on the DVD. Invite participants to complete the Video Viewer Guide for Week 3 in the participant workbook as they watch (page 105).

Group Discussion (25–35 minutes, depending on session length)

Note: More material is provided than you will have time to include. Before the session, select what you want to cover, putting a check mark beside it in your book. Page references are provided for questions related to questions or activities in the participant workbook. For these questions, invite participants to share the answers they wrote in their books.

Video Discussion Questions

- When was the last time you made up a "mental movie," imagining the worst-case scenario ending? How did it make you feel?
- How does each of our fighting friends (Peace, Courage, and Strength) help us to fight in faith in the battle against worry? How is fighting in faith different from trying to strong-arm situations or people?
- What is the three-step process that can help us train our fighting friends? Discuss some practical examples or ideas for acting on each step.

Participant Workbook Discussion Questions

1. Throughout the Bible, God tells us to stay away from anything that will draw our hearts away from Him. The Israelites are a forgetful people. Their time in the wilderness documents this fact again and again. So in order to protect their hearts as they are preparing to enter the Promised Land, God wants His people to acknowledge Him for this wealth of land that He has set before them. (Day 1)

 - Read Joshua 6:18. What would happen to the entire Israelite camp if anyone took anything dedicated to destruction? (page 74)
 - Now read Joshua 7:1. Who sinned and provoked God's anger against all of Israel? What did he do? (page 74)
 - Why do you think God sometimes prohibits the Israelites from taking the spoils of battle, including at Jericho? (page 74)

2. When our hearts melt in fear, a meltdown is confirmation that we believe we're all alone in our circumstance. A meltdown means that we cannot move forward—that nothing can be built upon us—in that moment. A meltdown isn't a permanent condition, but it's definitely a painful one for as long as it lasts. (Day 1)

 - Read Joshua 7:4-5. What happened to the Israelites when they went to fight at Ai, and what happened to the Israelites' courage? (page 75)
 - Recall a time when you had a meltdown. What happened? (page 76)
 - What do you think keeps us from inviting God into our uncertainty before we begin the worrying that leads to a meltdown? (page 76)

3. Even as the Israelites are in full-meltdown mode, God tells Joshua to get up. It's such a wonderful visual of God shaking Joshua out of his meltdown. God sends a sharp message to Joshua that God hasn't abandoned His promise to the Israelites.

 I love how God likes to get situations out into the open so that they can be dealt with. Sin likes to hide in the shadows, but the glory of God always exposes sin in order to heal us. (Day 2)

 • Read Joshua 7:13. God tells the Israelites that they will not experience victory until they do what? (page 78)
 • Read Joshua 7:19-21. What did Achan take from the spoils of the battle at Jericho? (page 79)
 • How has the glory of God exposed a lingering sin in your life in order to bring healing?

4. Achan's sin wasn't that he saw, it was that he wanted something that God didn't want for him and then took it. (Day 2)

 • Have you ever made a bad decision in fear because you were trying to secure or protect a good thing? If so, describe it briefly. (page 80)
 • How do you define *contentment*?
 • Imagine yourself in Achan's shoes. Perhaps you've never stolen something, but can you identify at all with his greed? Why or why not?

5. Peace comes to us through God's powerful words of assurance and security. You know that you're at peace when you're calm, even if chaos is happening around you. Peace begins with God. (Day 3)

 • Read Joshua 8:1. What's the first thing God says to Joshua? What assurance does God give Joshua? (page 86)
 • Read John 14:27. How does Jesus describe peace? (page 86)
 • Why do you think Jesus describes peace as a gift? How would you describe the difference between the peace that Jesus gives and the kind of peace you've tried to find on your own? (page 87)

6. When we're discouraged, we want to give up. Discouragement wants us to believe that failure is imminent and we should give up before it's too late. Discouragement also keeps us from the fight, because we don't believe that whatever we've got to offer will make a difference. (Day 3)

 • Is there a situation in your life that is discouraging to you right now? If so, describe it briefly. (page 88)

- How do we replace discouragement with courage? How did Joshua model courage at Ai?
- Think about the situation that is discouraging you right now. Can you identify one or two courageous moves that you can make in that situation? (page 89)

7. Often we think about strength only in physical terms, such as how much weight we can lift or how many reps we can do. Physical strength can be seen and measured, but we forget that spiritual and emotional strength are also observable. (Day 3)

- Read Joshua 8:18-26. How long did Joshua hold out his spear? (page 90)
- Think of a woman you know who is spiritually strong. How would you describe her strength? (page 91)
- Read Romans 5:3-4. How does God use our struggles in a positive way in our lives? (page 91)
- Read Ephesians 6:10. H*ow* are we to be strong? (page 91)
- Read Philippians 4:11-12. What do these verses tell us that Paul has learned [about strength]? (page 92)

8. Living the life God intends for us, which includes being victorious over worry, requires training. So, in order to battle worry we need to establish some new "work out" habits. There are some skills that can help us get into position for God's power to crush our worry. Our fighting friends—Peace, Courage, and Strength—need a training regimen so they will be prepared for battle when we need them most. If we don't work them out, then worry will wear us out! (Day 4)

- What does Barb mean when she says that "living the life God intends for us . . . requires training"?
- What are your current spiritual workout habits? Would you say that practices such as meditation, prayer, and obedience come easily for you? Why or why not?
- What would need to change in your schedule to allow for more meditation and prayer?

9. When I practice worry, I get weaker; but when I practice the promises of God, He gives me power. And when I remember what God says, I forget how to worry! (Day 4)

- How does worry make us weak?
- What does it mean to practice the promises of God? What are some ways we can do this?
- How would you describe the daily life of someone who has "forgotten how to worry"?

10. For many years, snacks smoothed over my worries and struggle. It took fasting to help me see that I had shifted my desire for comfort, ease, and peace to food instead of to deeper faith in God. (Day 5)

- Have you ever smoothed over your worries or struggles with food or some other vice instead of desiring more of God? If so, share about that time.
- How can fasting help us shift from seeking comfort to seeking God?
- Read Matthew 6:17-18. Are all believers supposed to fast? What phrase clues us into Jesus' answer? (page 102)
- If you have fasted in the past or currently practice the discipline of fasting, what have been some of the challenges you have experienced? (page 102)

11. When it comes to our worry battle, fasting is a secret weapon because it puts us in position for God to do deep work in our hearts, minds, and souls—where much of the worry we face is rooted. Fasting is a tool that God uses to dig up the dirtiest, crustiest roots of our worry. (Day 5)

- Discuss and share ideas about how fasting could fit into a weekly routine. What would this require or look like in your life with all you've got going on currently?
- What about fasting puts us in a position for God to do deep work in us?
- What are your current thoughts about fasting? Are you ready to try it? Do you need to learn more about it? What are some of your concerns about fasting? (page 102) Discuss some ways to encourage one another to grow in this spiritual practice.

12. Think about all of your study and reflection this week.

- What thoughts or discoveries are sticking with you from this week's study?

Deeper Conversation (15 minutes)

Divide into smaller groups of two or three for deeper conversation. (Encourage the women to break into different groups each week.) Before the session, write on a markerboard or chart paper the question or questions you want the groups to discuss:

- Where have you experienced victory in your worry battle this week?

- Review your notes from your Temperature Check Thursday. How are you doing with worry and anxiety this week? How have your "Fighting Friends" helped you gain courage and confidence?

Give a two-minute warning before time is up so that the groups may wrap up their discussion.

Closing Prayer (3–5 minutes, depending on session length)

Close the session by taking personal prayer requests from group members and leading the group in prayer. Consider encouraging members to participate in the Closing Prayer by praying out loud for each other and the requests given.

DEFEATING THE KINGS OF WORRY

Attacking the Roots of Our Worries
(Joshua 9–11)

Leader Prep

Bible Story Overview

This week we saw Joshua and the Israelites encounter a wave of new enemies as they faced a group of Canaanite kings who formed an alliance against them. Unlike the battles at Jericho and Ai where they faced one enemy at a time, now they are facing multiple kings and armies at once. Just as one king represents a certain level of power, a cohort of kings represents an exponential increase in power and capacity. Joshua might have been overwhelmed if he had not kept his heart and mind on God's plans and promises, which enabled him to boldly ask God to do the impossible. His "sun stand still" prayer encourages us to invite God to do what we do not have time or power to do on our own.

Main Point

God can give us victory over even the oldest and deepest worries. The supernatural power that God used to raise Jesus from the dead is the same supernatural power that God uses to give us victory over whatever king-sized drama is going in our lives.

Key Scriptures

"Do not be afraid; do not be discouraged. Be strong and courageous. This is what the LORD will do to all the enemies you are going to fight."

(Joshua 10:25 NIV)

[11]But listen carefully to everything I command you today. Then I will go ahead of you and drive out the Amorites, Canaanites, Hittites, Perizzites, Hivites, and Jebusites.

[12]"Be very careful never to make a treaty with the people who live in the land where you are going. If you do, you will follow their evil ways and be trapped.

(Exodus 34:11-12)

Jesus looked at them intently and said, "Humanly speaking, it is impossible. But with God everything is possible."

(Matthew 19:26)

But when you ask him, be sure that your faith is in God alone. Do not waver, for a person with divided loyalty is as unsettled as a wave of the sea that is blown and tossed by the wind.

(James 1:6)

What You Will Need

- *Joshua* DVD and a DVD player
- Markerboard or chart paper and markers
- Stick-on name tags and markers (optional)
- Smartphone or tablet and portable speaker (optional)

Session Outline

Welcome and Opening Prayer (2 minutes)

To create a warm, welcoming environment as the women are gathering before the session begins, consider lighting one or more candles, providing coffee or other refreshments, and/or playing worship music. (Bring a smartphone or tablet and a portable speaker if desired.) Be sure to provide name tags if the women do not know one another or you have new participants in your group. Then, when you are ready to begin, pray the following prayer or offer your own:

Dear God, thank You for Your constant presence and provision in our lives, and thank You for Your grace and mercy. Help us seek more and more of You and lay down our worries at Your feet. Open our hearts and minds to what You have for us today. Amen.

Icebreaker (3 minutes)

Invite the women to share short, "popcorn" responses to the following question:

- What would you do or accomplish if you didn't have to worry about time?

Video (20–25 minutes)

Play the Week 4 video segment on the DVD. Invite participants to complete the Video Viewer Guide for Week 4 in the participant workbook as they watch (page 141).

Group Discussion (25–35 minutes, depending on session length)

Note: More material is provided than you will have time to include. Before the session, select what you want to cover, putting a check mark beside it in your book. Page references are provided for questions related to questions or activities in the participant workbook. For these questions, invite participants to share the answers they wrote in their books.

Video Discussion Questions

- How has hurry been a root or source of worry in your life?
- What are some times or ways we experience secondhand worry (shouldering the responsibilities or wearing the worry of others)?
- What can we learn from Joshua's "sun stand still" prayer to help us in the battle against worry? Have you ever prayed a similar kind of prayer? If so, when?

Participant Workbook Discussion Questions

1. God is so kind to us! Just as He wanted the Amorites to turn from their sin and return to Him, God wants you and me to turn from our worried-filled, self-centered lives and follow Him. Let's be honest: on our own, we do a lousy job of leading our own lives. That's why we worry! And sin is a major root cause of that worry. Unfortunately, many of us also worry that God may not always be so kind to us. If we're honest, we sometimes worry that God might even punish us for messing up our lives—or at least leave us on our own to pick up the pieces. (Day 1)

 - Read Romans 2:4. What does this tell us about God's attitude toward our wrongdoing? (page 111)
 - Have you ever avoided God because you were worried that He might require something of you for your mistakes and sins—perhaps even take away someone or something you love? Why do you think we project these fears onto God when the Bible tells us over and over that God is Love?

- Review the abbreviated backstory of the generations from Noah to the time of Joshua (pages 109–111). How does the Israelites' conquest fulfill both the promise of God for a blessing and the fulfillment of righteous judgment in response to sin? Where do you see God's mercy at work?

2. As Christ shows you mercy by not giving you the punishment that you deserve, He also lavishly pours out His grace and love on you. That's His heart toward you!...He wants you to stop worrying about your past. That kind of worry is rooted in guilt over sin, but because of Jesus we can have complete confidence in God's great mercy! (Day 1)

 - Read 1 Timothy 1:14. What does God pour out abundantly on those who place their faith in Jesus Christ? (page 112)
 - What is the difference between grace and mercy?
 - According to Ephesians 2:4-7 and 1 Peter 1:3-4, what are we guaranteed because of God's mercy through Jesus Christ? (page 112) How can this promise give us confidence to overcome our deepest worries?

3. Secondhand worry is when we suffer the effects of worry because we are trying to carry the load that someone else should be responsible and accountable for managing themselves....We can wear ourselves out with secondhand worry when we do not recognize the difference between worry and concern. (Day 2)

 - Have you ever found yourself with a case of secondhand worry? If so, describe it briefly and how it affected your stress level.
 - Review your notes from Day 2. How did the Israelites demonstrate a case of secondhand worry?
 - What was the result of their secondhand worry?

4. As we train our fighting friends Peace, Courage, and Strength with God's promises, prayer, and the power of obedience, our hearts and minds will be in position to listen to God. In other words, these basic disciplines or habits attune our spiritual ears to hear God's voice. (Day 2)

 - How does fear or worry get in the way of us listening for God's leading? (page 117)
 - Describe a time when worry interfered with your ability to hear from God. (page 117)
 - What does it mean to listen carefully to God? (page 116)

5. Can you picture the Israelite people standing with their arms crossed, giving Joshua and the other leaders the stink eye? As a leader, that probably wasn't Joshua's most popular moment. But let's give the Israelite leaders their due recognition. For a group of people who are prone to wander from God's instructions, there are times when their resolve toward righteousness truly inspires me. (Day 3)

 - Read Joshua 9:21. What, specifically, do Joshua and the leaders decide to do with the Gibeonites? (page 122)
 - Can you think of a time when you were really worried about something and you did the wrong thing to try to fix it? If so, briefly describe it. (page 123)
 - What are some of the consequences you have faced because you acted wrongly—whether foolishly or sinfully—out of worry? (page 123)

6. When we trust God, He guides our way in life. If you feel lost in your life and aren't sure which way to go, ask God to tell you. The Holy Spirit leads and guides us into truth so that we know which way to go, even when life is uncertain. When we know that God will show us the way, we stop fearing for our lives; and that gives us the strength to love others. We love through generosity and compassion as imitators of Christ. And loving like Christ is one of the most powerful ways we can attack the roots of our worries! (Day 3)

 - Read Psalm 112 and name some of the blessings for those who trust and obey. (page 125)
 - Reread Psalm 112:7. What bad news are you trying to deal with right now? How can you see God taking care of you in this situation? What promises of God apply to what you are facing? (page 126)

7. Like Joshua, you and I have times in our lives when we're fighting to defeat certain challenges and wonder if we'll be able to hang in there until the end. But we can find encouragement in the takeaway lesson from this story: when we're accomplishing God's purposes for our lives, God runs the time clock. (Day 4)

 - Do you feel any pressure or worry when you think about your current schedule or the time line of a certain challenge? (page 130)
 - What do you worry about neglecting or not finishing? (page 130)
 - How fast do you feel that your life is moving right now? (page 130)

8. Joshua's request for the sun to stand still gives us some important insight into him as a man of faith. . . . He didn't ask God to make the sun stand still just so that he could defeat the enemy; he asked God to do the impossible because God is the One who sent Joshua on the mission in the first place. (Day 4)

 - Read Joshua 10:12-13. What does Joshua ask God to do? What happens, and how long does it last? (page 129)
 - What is something that seems impossible unless God steps in and empowers you to do it? (page 131)
 - Read Matthew 19:26 and James 1:6. What do these verses say about our ability versus God's ability, and what should we remember when we come before God? (page 132)

9. Like Joshua, your level of fear or worry will transmit to those who look up to you or depend on you. Conversely, as you fight for victory over fear and worry, you will provide an attractive model for others to follow. Even while fighting the battle, your example will speak volumes as you keep your mind focused on truth. (Day 5)

 - Read Joshua 10:25. What words did Joshua speak?
 - How do his words affect the hearers?
 - How do you speak life and freedom or fear and defeat to others with your words? Share some examples, if you are willing.

10. There are times in life when we don't feel equipped to deal with the problems we're facing. That's why we worry, right? Yet in those times when we feel ill-equipped and we elevate our prayers to the God who is fully able, we get to witness God's power and provision on our behalf. And when we tell the story of victory, God is the main character who receives the glory—rather than us siphoning off some of the praise for ourselves. (Day 5)

 - Read Genesis 15:1 and Isaiah 40:9-10 and identify the reason we don't need to be afraid. (page 136)
 - Read 2 Timothy 1:7. According to this verse, what has God not given us, and what *has* He given us? (page 137)
 - Read Zechariah 4:6. Can you think of a time when you were the underdog in a situation but God's Spirit helped you come out on top? (page 139)

11. Think about all of your study and reflection this week.

 - What thoughts or discoveries are sticking with you from this week's study?

Deeper Conversation (15 minutes)

Divide into smaller groups of two or three for deeper conversation. (Encourage the women to break into different groups each week.) Before the session, write on a markerboard or chart paper the question or questions you want the groups to discuss:

- Is there a victory that you've experienced this week in your battle over worry?
- When have you known God to take a little bit of faith to overcome a lot of worry?

Give a two-minute warning before time is up so that the groups may wrap up their discussion.

Closing Prayer (3–5 minutes, depending on session length)

Close the session by taking personal prayer requests from group members and leading the group in prayer. Encourage members to participate in the Closing Prayer by praying out loud for each other and the requests given.

CLAIMING OUR INHERITANCE

Receiving Our Victory
(Joshua 12–18)

Leader Prep

Bible Story Overview

This week we learned about claiming our inheritance and trusting God with our bold, big prayers. We learned that Joshua and the Israelites defeated thirty-one kings. Though each of those kingdoms lost their king in battle, the Israelites did not completely drive out the people as God commanded; and we will see that the failure to follow through on God's orders would hold tremendous consequences for His people in time.

Main Point

We can clear out all of the worry in our lives by fighting in faith; and when we apply those same faith tools in other struggles, we can be victorious in those areas of our lives as well. We don't have to settle for less than God's best; God will give us victory over all!

Key Scriptures

"For my part, I wholeheartedly followed the LORD my God."

(Joshua 14:8b)

For the LORD your God is living among you.

 He is a mighty savior.

He will take delight in you with gladness.

 With his love, he will calm all your fears.

He will rejoice over you with joyful songs.

 (Zephaniah 3:17)

²They came to them at Shiloh in the land of Canaan and said, "The LORD commanded Moses to give us towns to live in and pasturelands for our livestock." ³So by the command of the LORD the people of Israel gave the Levites the following towns and pasturelands out of their own grants of land.

 (Joshua 21:2-3)

So if you sinful people know how to give good gifts to your children, how much more will your heavenly Father give good gifts to those who ask him.

 (Matthew 7:11)

What You Will Need

- *Joshua* DVD and a DVD player
- Markerboard or chart paper and markers
- Stick-on name tags and markers (optional)
- Smartphone or tablet and portable speaker (optional)

Session Outline

Welcome and Opening Prayer (2 minutes)

To create a warm, welcoming environment as the women are gathering before the session begins, consider lighting one or more candles, providing coffee or other refreshments, and/or playing worship music. (Bring a smartphone or tablet and a portable speaker if desired.) Be sure to provide name tags if the women do not know one another or you have new participants in your group. Then, when you are ready to begin, pray the following prayer or offer your own:

Dear God, we are so grateful that Your very presence is our inheritance. You have always been faithful, and we confess that we have not. Help us to set aside our worries and set our eyes on Your promises. Amen.

Icebreaker (3 minutes)

Invite the women to share short, "popcorn" responses to the following question:

- What would you do if a lawyer called to share the surprise news that you have an unclaimed inheritance? Would you travel? pay off debt? set up a college fund? go on a shopping spree?

Video (20–25 minutes)

Play the Week 5 video segment on the DVD. Invite participants to complete the Video Viewer Guide for Week 5 in the participant workbook as they watch (page 173).

Group Discussion (25–35 minutes, depending on session length)

Note: More material is provided than you will have time to include. Before the session, select what you want to cover, putting a check mark beside it in your book. Page references are provided for questions related to questions or activities in the participant workbook. For these questions, invite participants to share the answers they wrote in their books.

Video Discussion Questions

- Has fear or worry ever convinced you to settle for less than God's best? If so, when?
- Where are the particular places where you tend to settle for less than God's best?
- As we battle worry after worry, what gives us hope? How can we claim God's victory?
- Which worry driver tends to give you more trouble—weariness, compromise, apathy, doubt—and why?
- Practically speaking, how can we fight for God's promises and claim our inheritance?

Participant Workbook Discussion Questions

1. There are times when I just want God to kick my worry in the teeth and make it go away once and for all. But then I remember that when I battle worry, it causes me to worship my worry right out the door. Fighting worry requires my constant submission to God's way of life, the choice to be obedient to God, and a commitment to the tools and disciplines that help win the fight. And just because I've gotten in position and experienced God's power over worry in one area does not mean that victory applies to other areas. I know I have to reposition myself for other worry battles, too. (Day 1)

 - How are you doing today when it comes to your worry battle? Are you energized, feeling battle weary, or close to giving up? (page 145)
 - As you reflect on your life, what is harder for you to endure: occasional major worries or persistent minor worries? Why? (page 144)

- Read Romans 8:35, 37. What struggles have been a part of your life? What kind of victory are we promised in spite of these struggles? (page 144)

2. There are more than four hundred references to singing in the Bible, as well as dozens of direct commandments to sing. And of course, there's the Book of Psalms, which is a collection of songs. God sings, and He wants us to sing, too. There are a few good reasons why we should sing, especially when we're in the midst of battling worry. But the big takeaway is that when we sing to God, the music ministers deep within our souls to uplift and encourage us. (Day 1)

 - How has music been a source of encouragement in your own struggles?
 - What are some verses in the Psalms that can lift you out of a worry spiral?
 - Read Zephaniah 3:17. What kind of songs does God sing—and where does He sing them? (page 146)

3. We've acknowledged that at different times throughout our lifetimes, we will have skirmishes with worry about different things. But when we think about our current worry battle, our goal always should be to eliminate 100 percent of the worry about the particular situation or concern. We can't harbor a little fretting here or there because a little bit of worry is still worry. Likewise, a little bit of worry will eventually grow into a giant panic and meltdown. (Day 2)

 - Read Matthew 5:8. Do you think it is possible to keep a pure heart if we allow even the smallest splinters of worry to remain in place? Explain. (page 149)
 - Have you ever held on to a small bit of worry because you just couldn't let it go? What did that do to your heart?
 - Have you ever made it a goal to eliminate 100 percent of worry? How are you learning to move toward that goal?

4. If we think back to the Israelites' victories at Jericho and Ai, we see no evidence of these worry drivers. In fact, we see their opposites—our fighting friends Peace, Courage, and Strength. As we've learned, these are the friends who can help us fight in faith whenever weariness, compromise, apathy, or doubt try to drive us back to worry. Thankfully, we can enlist the help of these fighting friends to push back the worry drivers and gain victory over this recurring worry once again. . . . Once we experience God's victory over worry, we are unsatisfied with going back to that kind of captivity. We must acknowledge that even a little bit of worry is still worry and erosive to our freedom. . . . There will be times when

worry will bust through the door of our hearts and minds, but we always have immediate access to the power to drive worry right back out! (Day 2)

- Read Philippians 4:6-7. What does God want you to know today as you reflect on these verses? (page 152)
- Review the list of potential reasons that may have kept the Israelites from driving out the Canaanites completely on page 151. How do the four worry drivers—weariness, compromise, apathy, and doubt—keep you from complete freedom from worry?
- How can our fighting friends of Peace, Courage, and Strength help us to combat these worry drivers?

5. Imagine with me the first morning that Joshua wakes up without a new battle to fight. Perhaps as he opens his eyes and stretches his arms overhead, he realizes that he doesn't have to meet with his military officers. Instead of jumping up and calling for reports from his officers, I imagine him taking his time getting dressed and enjoying the Israelite equivalent of a leisurely cup of coffee. Later he might have the chance to visit with the families of some of the fighting men and to see the happy looks on their faces now that the fighting years are over. (Day 3)

- Read Joshua 11:23. What does this verse say about Joshua's current state of affairs?
- Read Joshua 13:1. What does God say about Joshua's age? (page 156)
- What else does God say in this verse about the state of the Israelites' campaign in the Promised Land? (page 156)

6. Your inheritance is waiting, but there is a catch: you must claim it. It has to be accepted, which means you must take possession of it. An inheritance is not fully realized until it is in the hands of the new owner. (Day 3)

- What is a promise or blessing of God that you are ready to receive or experience in your life? (page 158)
- What's the difference between *knowing* that you have a promise or inheritance and actually *claiming* or *receiving* it? (page 159)
- Read Joshua 13:2-8. What was Joshua's role in granting an inheritance to inhabitants living in the land?

7. God Himself will be the inheritance for the Levites, and He promises to provide for them by giving them the tithes [offerings] of Israel. This is the provision

given before they enter the Promised Land; yet when it is time to settle into the land, God makes another special provision for the Levites. (Day 4)

- Read Numbers 18:20-21. What does God tell Aaron about the Levite land allotment? (page 160)
- Read Joshua 13:14. How else will God provide for the Levites? (page 160)
- Read Joshua 21:2-3. Rather than an assigned land inheritance, the Levites will live in various cities. Who gives the Levites these places to live? (page 160)

8. Rather than try to arrive at a fancy solution or succumb to the tribes' complaints, Joshua sticks with God's plan. He presents the two tribes with the same instructions that God gave the entire nation of Israel, telling them that they are strong enough to fight for their land, remove the inhabitants, and claim it as their own.

There are times when we think that our problems are special and, therefore, that few others could understand our complex predicament. Often when we're sharing our worry with someone, we find ourselves using the phrase, "But you don't understand…"

Sometimes we take that same tone with God. When we have a worry before us, we may think that God's wisdom falls short of our situation. But it never does. (Day 4)

- Read 1 Corinthians 1:25. How does God's wisdom compare to our human wisdom? (page 163)
- Read Joshua 17:18. How do you think this verse translates to your worry battle? (page 164)
- As you reflected on your worry battle, did any victorious moments come to mind? Refer to your responses on page 162. What did it feel like to know that God gave you victory to beat back worry and live worry-free in that situation or situations? (page 162)

9. As the leader assigned to assist in the division of land among the families of the tribe of Judah, Caleb would have quite a task assigning individual plots of land to individual families. Yet despite this significant responsibility, Caleb takes time to go to Joshua to claim a promise made to him long ago. (Day 5)

- Read Joshua 14:10-14. How old is Caleb at the time he presents himself to Joshua to claim his inheritance? How does he describe his physical health? (page 167)
- Who is someone of a mature age that you admire for his or her passion and faith? Describe what you admire about this person. (page 168)

10. To be victorious in the worry battle, we must worry less about God saying no if we make the "big ask." Trust is essential for a life of freedom. But for many of us, what we fear more than the thought of God saying "no" is the possibility that He may answer our prayers in a way that we don't want. (Day 5)

- Read 1 John 3:1 and Matthew 7:11. What kind of love does God pour out on His children? What kind of gifts does God give to His children? (page 171)
- Read James 4:2-3. What are the two reasons that we don't have what we want? (page 169)
- What have you been afraid to ask God for lately? How has your lack of courage to ask God for it caused you to worry? (page 169)

11. Think about all of your study and reflection this week.

- What thoughts or discoveries are sticking with you from this week's study?

Deeper Conversation (15 minutes)

Divide into smaller groups of two or three for deeper conversation. (Encourage the women to break into different groups each week.) Before the session, write on a markerboard or chart paper the question or questions you want the groups to discuss:

- Is there a victory that you've experienced this week in your battle over worry?
- Review your notes from the Tool Tuesday AAR exercise. Discuss your thoughts and insights after charting out your worries and victories.

Give a two-minute warning before time is up so that the groups may wrap up their discussion.

Closing Prayer (3–5 minutes, depending on session length)

Close the session by taking personal prayer requests from group members and leading the group in prayer. Encourage members to participate in the Closing Prayer by praying out loud for each other and the requests given.

AMEN!

Living in Victory
(Joshua 18–24)

Leader Prep

Bible Story Overview

The Book of Joshua has four phases: arrival, acquisition, allotment, and allegiance. And this week we focused mostly on allotment as we studied chapters 18–24, where most of the tribes are in a holding pattern. They have been assigned their inheritance, but since they haven't been obedient to God's command to completely drive out the enemy, they aren't experiencing the total and promised victory. As we examined this part of their story, we discovered that some worry drivers—weariness, compromise, apathy, and doubt—are undermining the Israelites' pursuit of all that God has promised them. We also witnessed Joshua's rally cry for their allegiance to God as he passes the mantle of leadership to the next generation along with several important reminders.

Main Point

Victory over worry is a choice we make every day as we choose to worship God. As long as we remember that God is with us and for us in every circumstance, we will always win over worry. He has promised to give us victory over worry in *every* area of our lives.

Key Scriptures

"You are a witness to your own decision.... You have chosen to serve the Lord."

(Joshua 24:22)

*"So fear the L<small>ORD</small> and serve him wholeheartedly. Put away forever the idols your
ancestors worshiped when they lived beyond the Euphrates River and in Egypt. Serve
the L<small>ORD</small> alone. ¹⁵ But if you refuse to serve the L<small>ORD</small>, then choose today whom you will serve.
Would you prefer the gods your ancestors served beyond the Euphrates? Or will it be the
gods of the Amorites in whose land you now live? But as for me and my family, we will serve
the L<small>ORD</small>."*

(Joshua 24:14-15)

What You Will Need

- *Joshua* DVD and a DVD player
- Markerboard or chart paper and markers
- Stick-on name tags and markers (optional)
- Smartphone or tablet and portable speaker (optional)

Session Outline

Welcome and Opening Prayer (2 minutes)

To create a warm, welcoming environment as the women are gathering before the session begins, consider lighting one or more candles, providing coffee or other refreshments, and/or playing worship music. (Bring a smartphone or tablet and a portable speaker if desired.) Be sure to provide name tags if the women do not know one another or you have new participants in your group. Then, when you are ready to begin, pray the following prayer or offer your own:

Dear God, thank You for the witness of Joshua, who shows us how to follow You faithfully. Help us to recall and put into practice all that we have learned, remembering that leaning into Your faithfulness is a better choice than worry. Speak to us what we need to hear as we conclude our study today, Lord. Amen.

Icebreaker (3 minutes)

Invite the women to share short, "popcorn" responses to the following question:

- What time of year seems to bring about the busiest, most worry-filled season for you—holidays, back to school, vacations? Why?

Video (20–25 minutes)

Play the Week 6 video segment on the DVD, pausing after the prayer before Barb's final closing segment (you will play this segment as the Closing Prayer of the session). Invite participants to complete the Video Viewer Guide for Week 6 in the participant workbook as they watch (page 202).

Group Discussion (25–35 minutes, depending on session length)

Note: More material is provided than you will have time to include. Before the session, select what you want to cover, putting a check mark beside it in your book. Page references are provided for questions related to questions or activities in the participant workbook. For these questions, invite participants to share the answers they wrote in their books.

Video Discussion Questions

- How or why is victory over worry a choice?
- What does it mean to say that the victorious life is a life of worship?
- What are some everyday, practical ways we can choose worship over worry? Give some examples from your own life, if possible.
- What role do other believers play in helping us to hold onto victory over worry?

Participant Workbook Discussion Questions

1. The entire nation of Israel meets at Shiloh, which is located on the mid-eastern side of Ephraim. Though a number of the twelve tribes have already received allotments, it is important for the Israelites to remember their unity as a people instead of running after their individual interests. (Day 1)

 - Read Joshua 18:2-6. What have they not done yet? How will Joshua divide the land? (page 176)
 - What does it mean to "cast lots" to divide the land?
 - Read Proverbs 16:33. Even though a lot is cast, who determines the decision? (page 177)

2. It's important to note that, as the leader of the campaign into the Promised Land, Joshua could have stood up at the start of the land allotments and said, "Me first!" But he didn't. It wasn't until all of the land had been given that Joshua selected his inheritance. This is the mark of a true servant leader—after the example of Jesus. (Day 1)

 - Read Joshua 19:49-51. What had God said that Joshua could have, and who gives it to him? (page 179)
 - What city does Joshua choose? Where is it located? (page 180)
 - Read Ephesians 2:5-9. What are the humble attitudes that Christ modeled for us? (page 180)

3. Even as the Promised Land is the new home of the Israelites, God acknowledges that not everything will be perfect in their new residence. So God sets up safeguards to protect the people from some of the consequences of our broken

world and prevent needless worry when an unspeakable accident happens. (Day 2)

- Read Joshua 20:1-3. Why does God instruct the people to establish cities of refuge? (page 181)
- What example is given in Deuteronomy 19:5 for why a person might need a city of refuge? (page 181)
- What did you learn about cities of refuge? What kind of current legal systems might compare to cities of refuge?

4. In a spiritual sense, we need a place of refuge, too, a place where we find forgiveness from sin; and because of Jesus, we have that place. (Day 2)

- Read Hebrews 4:16. Where are we to go boldly and receive mercy and grace in our time of need? (page 182)
- Read 1 Peter 3:18 and 1 John 2:1-2. What do these verses tell us about how Jesus made this possible? (page 182)
- Would you say that you feel empowered to go God with boldness? Why or why not?

5. Choosing to open up our lives and allow people to celebrate with us, share concerns they have about us, or even correct us is hard. Most of us shy away from it. But you'll never hold on to your hard-fought victory over worry without someone in your life checking in on you with regularity. (Day 3)

- When has a close friend or "heart sister" helped you through a battle with worry?
- How can you be someone who steers friends away from the worry pit?

6. I know from experience that when there is uncertainty in a matter, it takes a lot of bravery to approach another believer and, in love and respect, ask questions about the veracity of their faith. I've been on both sides, and it's hard. Yet this is exactly what God calls us to do. (Day 3)

- Read Galatians 6:1-3. What are we to do when we see another believer struggling with sin? What two attitudes should guide our approach in helping them? What is the warning for us in verse 1? (page 188)
- What do we need to remember if we think we are too good or important to help those who are caught in sin? (page 188)

- Have you ever approached someone in love to express your concern for them? If you have, how did it go? If you haven't, what are your concerns or worries about that type of conversation? (page 189)

7. Joshua 23 opens with the notice that a long time has passed since the end of the giving of the land inheritances. All of the nation of Israel has been summoned together. Now Joshua is an old man, and he is ready to pass along the mantle of leadership to the next generation with several important reminders. (Day 4)

 - Read Joshua 23:6-13. What were the reminders Joshua spoke to the people? (page 192)
 - Read Joshua 23:14-16. What does Joshua say about God's track record regarding the promises made long ago? (page 192)
 - What last bit of advice would you want to pass on to people you love?

8. The phrase "choose today whom you will serve" is often misunderstood as a choice between God and other gods in general. But read carefully and you'll see that it's not a question of either/or but a question of who, specifically. Notice that Joshua has already implored the people to serve God wholeheartedly and abandon worshiping other idols. He calls them to serve God only, and yet they have the free will to decide what they will do. So, if they do not want to serve God, Joshua tells them to take their pick of the gods that they could serve. (Day 4)

 - Read Joshua 24:14-15. What is Joshua telling the people to do? What choices are the people given? (page 194)
 - What woos you away from choosing God each day? (page 195)
 - What does it mean to follow after God wholeheartedly?

9. When I read the people's response to Joshua here in the final chapter, I want to applaud them because they sound as if they are responding in strong faith and conviction. After all, they've seen God do great and mighty things in their midst. They also are acknowledging how God has done great and mighty things prior to their time. Yet Joshua knows the true hearts of the people.

 Joshua looks at the people and basically says, "Are you sure? You know that if you say you choose God, then you must choose Him each and every day. Is that the commitment you really want to make?" (Day 5)

 - Read Joshua 24:19-20. How does Joshua describe God? What does he say will happen to the people if they forsake God to follow other gods? (page 198)

- Read Joshua 24:21-28. When Joshua tells the people that they are the witnesses to their own decision to serve God, how do they respond? What does Joshua do to confirm the people's decision? (page 198)
- What will serve as the reminder of their agreement, and where is this reminder or witness placed? (page 199)

10. As followers of Jesus, we live under the new covenant. Because of Jesus' sacrificial death on the cross, we are forgiven when we sin against God. Unlike the old covenant of rules, the currency of the new covenant is God's grace and our faith. This covenant is sealed by our faith in Christ and His finished work on the cross, and it is eternal. The new covenant covers every area of our lives. But we also can make our own covenants with God—agreements about specific areas of our lives that we are committing to work on with the help of the Holy Spirit. (Day 5)

- Read Isaiah 29:13. How does God describe the difference between His people's hearts and words? (page 199)
- How can we make a covenant with God to make our hearts, words, and actions reflect our relationship with God?
- How could making a covenant to give up worry lead you to victory?

11. Think about all of your study and reflection this week.

- What thoughts or discoveries are sticking with you from this week's study?

Deeper Conversation (15 minutes)

Divide into smaller groups of two or three for deeper conversation. (Encourage the women to break into different groups each week.) Before the session, write on a markerboard or chart paper the question or questions you want the groups to discuss:

- How have you experienced victory over worry this week?
- Look at your two Worry Wheels on pages 33 and 196. What differences do you notice? Any growth? Any struggles? How have spiritual practices helped you to win over worry?

Give a two-minute warning before time is up so that the groups may wrap up their discussion.

Closing Prayer (3–5 minutes, depending on session length)

Close the session by resuming the video where paused to play Barb's closing segment (or replay that closing segment if you watched it earlier). Invite the women to receive her prayer as a final blessing and benediction. If you wish, follow this with your own brief time of prayer together.

VIDEO VIEWER GUIDE ANSWERS

Week 1
Insecurity
Personal
Provisional
Spiritual
with/for
What if/God if

Week 2
limitations
turn/God
knows
always/stands
brings
deserve
worry/pray
peace
Fix/God/wants

Week 3
security
commitment
empowers
Study
Meditate
Obey
God
hold/you

Week 4
priorities
fight
impossible
limit/tool
frantic
actionable/steps

Week 5
battle
plan/promises
Weariness
Compromise
Apathy
Doubt
drive/them/out
back/in
God's/best
old
others/blessed

Week 6
surround/ourselves
faithful
worship

GROUP ROSTER

Name	Phone Number	E-mail

1. _____

2. _____

3. _____

4. _____

5. _____

6. _____

7. _____

8. _____

9. _____

10. _____

11. _____

12. _____

13. _____

14. _____

15. _____

Be Victorious Over Worry in Your Life!

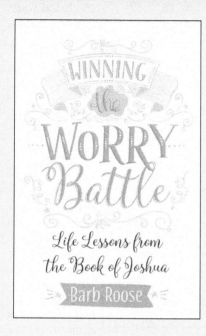

Winning the Worry Battle:
Life Lessons from the Book of Joshua

Paperback ISBN: 9781501857843

Have you ever tried to fight worry and felt you were losing the battle? Combining inspiration, humor, and personal stories, Barb offers real encouragement for handling life's concerns that cause us to struggle with worry, anxiety, and fear. Inspired by the Book of Joshua, she equips us with Scripture-based, practical tools to bravely battle worry and overcome the struggles we all face. The book provides examples of how God gave the Israelites victory over their enemies and generously blessed them. As we read their story, we too, will be victorious in our fight of faith.

Also from Barb Roose . . .

Beautiful Already: Reclaiming God's Perspective on Beauty

Workbook ISBN: 9781501813542

Explore God's truth about beauty throughout the Scriptures in this engaging Bible study.

Enough Already: Winning Your Ugly Struggle with Beauty

Paperback ISBN: 9781426789014

Recognize your own outer and inner beauty as defined by God, not the media or others in Barb's impactful book.

Get sample chapters and the complete first session of her studies at
AbingdonWomen.com/BarbRoose